HIPSTER STREET LIFE

&

ANIMALS BEING WILD

COLORING BOOK

Hipster STREET LIFE Coloring Book

ANIMALS

Being Wild

Coloring Book

www.ingramcontent.com/pod-product-compliance
Lightning Source LLC
Chambersburg PA
CBHW081208180526
45170CB00006B/2261

* 9 7 8 1 5 2 2 9 6 9 1 7 4 *